UNDERSTANDING VALUES

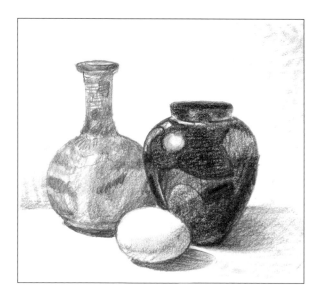

By Ken Goldman

Walter Foster Publishing, Inc.
23062 La Cadena Drive
Laguna Hills, CA 92653
www.walterfoster.com

D1400643

CONTENTS

INTRODUCTION

This is not just a "how-to" book; it is a "how-to-see-and-do" book. When seeing and drawing shapes and their values—lightness or darkness—you are not drawing "things." Rather, you are creating areas of value as various shapes; those shapes become recognizable only when they are drawn accurately in combination with other shapes. This is an effective, time-tested approach, but its application requires some rethinking of childhood drawing preconceptions, as well as discipline in seeing and drawing differently.

The exercises in this book will take you through a step-by-step process of seeing shapes, identifying their light and dark values, and fitting the pieces together to form recognizable images. By seeing and drawing objectively, rather than by thoughtlessly copying, you will be able to create a realistic subject.

I divide seeing and drawing shapes and values into both theory and practice, but I mostly emphasize practice. In this book, you will find helpful hints and step-by-step demonstrations for getting started, seeing values, placing accurate shapes, arranging values, rendering the perspective of shadows, creating depth and focal points, using the elements of design, and moving the viewer's eye through the drawing. We will work with a range of subjects—flowers, wildlife, still lifes, portraits, figures, architecture, and landscapes. I hope you will enjoy these simple, but interesting, projects.

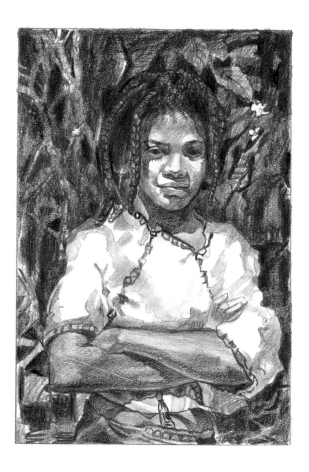

GETTING STARTED

I find the best way to acquire a long-standing interest in drawing is to have an ongoing project and a private, cozy place to work. You should be able to work whenever the mood strikes you, for any amount of time, and to know that no one will disturb your area between drawing opportunities. I have a large studio for painting, but my drawing area actually is very small. My personal experience is that space is not really the main issue in creativity. All the drawings in this book were done on a surface no larger than a card table with the materials pictured on this page.

Materials

A few basic materials are all you need to start drawing. You can find a variety of types and sizes of sketchbooks in art supply stores. I prefer a 9" x 12" spiral-bound sketchbook. Seven different pencils—6H, 4H, 2H, HB, 2B, 4B, and 6B—allow me to produce varying values, from delicate shadings to velvety blacks. I use both a small and a large paper stump (or *tortillon*) for blending strokes and softening edges. Kneaded erasers are useful for dulling areas, lifting out lights, and delicately erasing small areas. You can use a pink rubber or white vinyl eraser for serious erasing, but be careful—they can damage delicate paper! A metal erasing shield is a great tool for cleaning up small, isolated areas; making interesting textures; and creating hard edges.

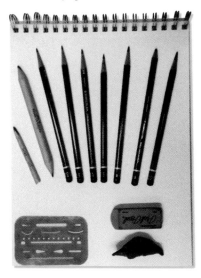

Starting with the Basics Here are my basic drawing materials—paper, pencils, tortillons, erasers, and an erasing shield.

Work Station

My work station functions well for working with both photos and actual objects. When creating a still life, I arrange my objects in a *still life box*. This box serves as a "stage" on which I can produce various effects with lighting and backdrops (see page 23). I constructed the still life box shown on this page from three pieces of foam core (two 12" x 16" rectangles for one side and the base, plus one 12" x 12" square for the remaining side), held together with clear packing tape. I set the still life box on a sturdy box against which I have leaned a foam core drawing board, placing everything at a comfortable height for me to sit and work. To draw from a photo, I simply place a table easel in the still life box. The clips on the easel are useful for raising a small image closer to eye level.

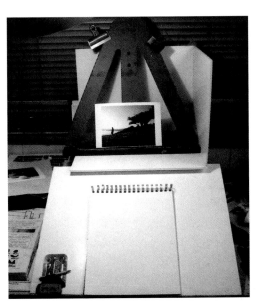

Setting Up a Work Station This is my setup for drawing from a photo. To draw a still life, I remove the easel and arrange my subject in the still life box.

Hand Positions

All artists use at least one of the hand positions shown on this page. As I develop this picture of a kangaroo rat grooming itself, the drawing goes through four definite stages. These are the basic hand positions I use for each stage:

Mid-Underhand Position This is a good position for making initial, loose gestures where precision is not required. My whole arm moves from the shoulder. (This hand position takes some getting used to.) I draw the basic outline of the rat using this position.

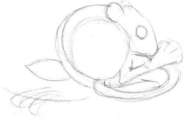

Handwriting Position This position allows me to draw careful contour lines. I hold my hand as I would for writing a letter. Because the drawing is not very developed yet, I don't need to worry about smudging.

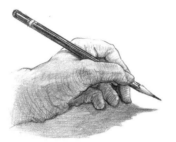

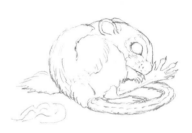

Low Underhand Position For this position, I hold the pencil so low that my knuckles practically drag on the paper. The resulting angle allows me to shade in the light and dark values with the side of my lead. I also use this position to shade in a dark, beady eye with the point of the lead.

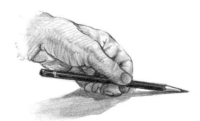

Stabilized Handwriting Position This position is basically the same as the handwriting position, except that I use my pinkie rather than the side of my hand for stability. This works well for adding final, smudge-free details. I use this position to depict the texture of the kangaroo rat's fur.

Basic Strokes

The moment your pencil touches paper, you have made a statement. Value, line, texture, and shape are elements that you, the artist, can use to convey ideas. In this drawing, I use various strokes to depict a rabbit sitting alertly in a field. In artistic terms, the recognizable shape is a rabbit, surrounded by various combinations of textures, values, and lines that tell us about the field. Practice these strokes and note how and where they are used throughout this book.

Adding Texture Note the effect created in the drawing by each basic stroke shown here. Experiment with a blending stump to see which additional textures you can create.

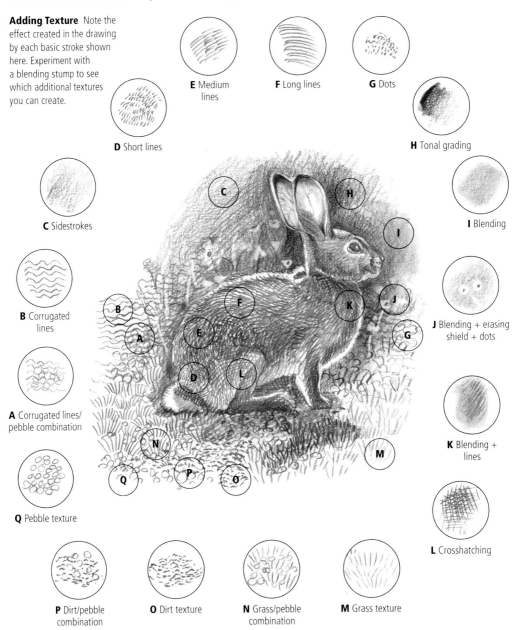

E Medium lines

F Long lines

G Dots

D Short lines

H Tonal grading

C Sidestrokes

I Blending

B Corrugated lines

J Blending + erasing shield + dots

A Corrugated lines/pebble combination

K Blending + lines

Q Pebble texture

L Crosshatching

P Dirt/pebble combination

O Dirt texture

N Grass/pebble combination

M Grass texture

UNDERSTANDING VALUE AND SHAPE

Value is defined as the relative lightness or darkness of a color or of black. In nature, values have infinite *gradations,* or degrees. The shapes that we see are a result of these changes in value. Because artists cannot visually comprehend such unlimited subtleties, they reduce nature's vast scale into values that they easily can see. Many artists use a scale of nine values ranging from black through gray to white. I often use only five: highlight, light, medium, dark, and low dark.

Establishing a Value Scale

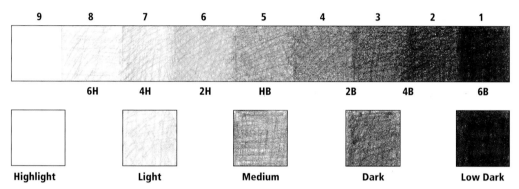

Rendering Values The nine-value scale shows the transition from white through gray to black. The numbers and letters underneath the scale show you which pencils I use for each value. The 6H is the hardest lead and barely makes a mark; it works well for delicate shading, such as value 8. The 4H is slightly softer and, depending on how much pressure you apply, will create values 8, 7, and 6. The 2H is good for light lay-ins; it works well for value 6, and its soft lead will not leave grooves in fragile paper. The HB is my favorite pencil for all-around drawing, and it's perfect for the middle-value 5. The 2B has a wide range: It represents values 4 and 3 on the scale. The 4B is a soft, dark pencil that corresponds to values 3 and 2 on the scale. The 6B is slightly darker than the 4B; it creates a velvety black corresponding with value 1, but it easily breaks when being sharpened.

Recognizing Shapes

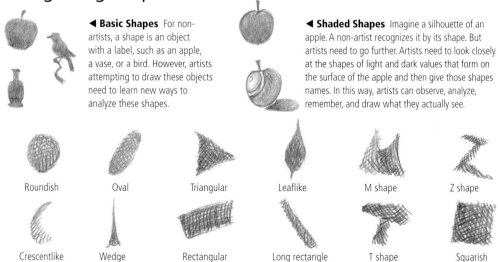

◄ **Basic Shapes** For non-artists, a shape is an object with a label, such as an apple, a vase, or a bird. However, artists attempting to draw these objects need to learn new ways to analyze these shapes.

◄ **Shaded Shapes** Imagine a silhouette of an apple. A non-artist recognizes it by its shape. But artists need to go further. Artists need to look closely at the shapes of light and dark values that form on the surface of the apple and then give those shapes names. In this way, artists can observe, analyze, remember, and draw what they actually see.

| Roundish | Oval | Triangular | Leaflike | M shape | Z shape |
| Crescentlike | Wedge | Rectangular | Long rectangle | T shape | Squarish |

Abstract Shapes These are random examples of shapes you may see in various objects and suggestions for names you can use to help you remember what shapes you intend to draw. By learning to carefully place shapes you actually see, you will gain the type of objectivity that is necessary to draw anything in front of you.

SEEING VALUES

There is a saying among artists: "Color gets all the attention while value does all the work." Whether you draw an object with a two-, five-, or nine-value scale, it is value, not color, that is mainly responsible for the visual strength of the image. With practice, you can train yourself to view objects and scenes in terms of their values.

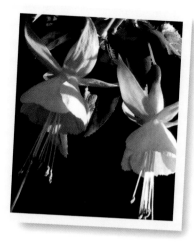

▶ **Translating Color to Value** This photo of fuchsia was shot in brilliant color. But the range of values is what gives the image strength in black-and-white.

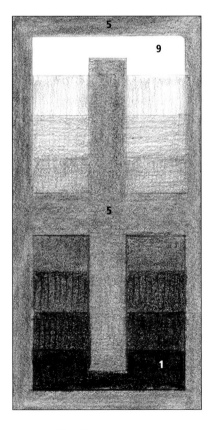

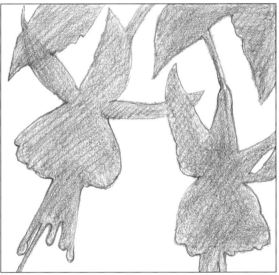

▲ **Simplifying Values** The first stage in seeing values is to simplify. Two values (white and a middle-value 5 gray) are perfectly adequate to convey the idea of this fuchsia. Note how the light and dark areas of the silhouettes resemble certain shapes on page 7.

▲ **Recognizing Contrasts** An artist can achieve a wide range of contrasts with the help of *simultaneous contrast*—the illusion that a middle-value (5) gray appears darker when surrounded by white (9) and lighter when surrounded by black (1). (The middle-value gray column and border in this image actually have the same value from top to bottom and all around.)

TIP

Using a variety of strokes and hand positions gives a distinctive value quality to different shapes (as shown on page 10). For instance, I darken the leaves with sidestrokes and lift out the veins with a kneaded eraser (below left); I use crosshatching to effectively render the petals (below right).

Using Lines as a Shorthand for Value

Lines do not exist in nature, but they certainly exist in my drawings! I use lines as a shorthand method for transferring nature's three-dimensional world of light and dark onto my two-dimensional paper.

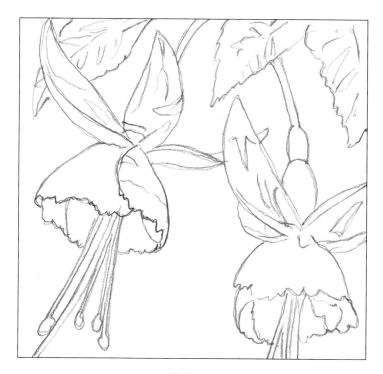

Representing Shapes with Lines The second stage in learning to see values is to find and draw the shapes within the overall form. Compare the flat, outlined silhouette on the opposite page with this line drawing. Instead of having a middle value, I add internal lines that break up the large main shape of each flower into smaller shapes, creating a linear sense of three dimensions and overlapping.

Combining Value and Line
This drawing represents the third stage in seeing values. It combines the two values of the first stage with some of the lines from the second stage to further divide the shapes into smaller areas. Look back at page 7 and see how many shapes you can identify in the line drawing above. Next, look at the photograph on page 8. Compared with the photo's complexity of small veins, frills, and details, it's much simpler to begin a drawing with large, simple shapes like these.

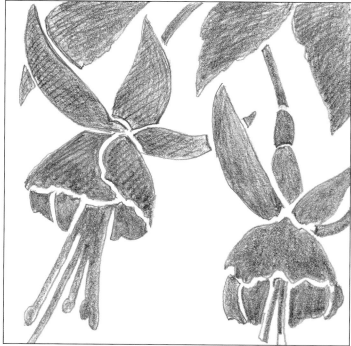

Introducing a Third Value

As I begin to render additional details to the shapes of light and shadow, I add a third value. This new, slightly lighter value allows me to incorporate the transitional subtleties that help give the fuchsia a sense of volume. Crosshatching and sidestrokes are two of my favorite methods for building up lights and darks. Try some of the strokes and textures shown on page 6 to see the effects you can create.

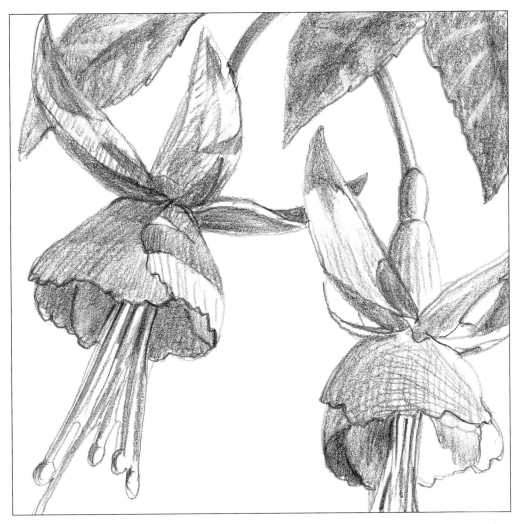

Creating Transitions Through the addition of a third middle value, the image begins to assume depth and volume. Because there are no areas darker than value 6, I can use an HB pencil for the whole drawing. The HB pencil is soft enough to make darks but also hard enough to render delicate lights, such as the outer petal of the left-hand flower and the inside petal of the right-hand flower.

Adding a Lighter Middle Value For this version of my drawing, I add value 6, one step lighter than the middle-value 5 used in the earlier drawings.

Creating Drama with Additional Values

Compare the final drawing on this page with the three-value drawing on the opposite page. By adjusting the middle values to 7 and 4 and using black (1), I add both contrast and transition, bringing this version closer to the actual photo. This is an important point: How much should an artist deviate from a reference? The answer is that it depends on what degree of "finish" an artist prefers. Some artists like to copy a photo just as it is, and that's fine. The main difference between a photographic, realistic interpretation and the drawing on this page is that a super-realist will use the full value scale with its subtle gradations, whereas a drawing like this one uses only four values, resulting in less subtlety but more drama.

Adding Contrast The four values used for the final drawing are 9, 7, 4, and 1.

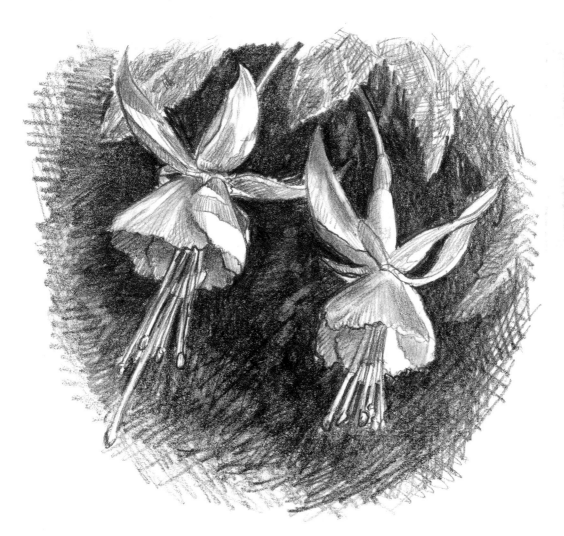

Interpreting the Subject Although the values in this drawing are similar to those in the photo, my use of looser, cross-hatched strokes makes this rendering more of an artistic interpretation than a strict copy.

PLACING SHAPES ACCURATELY

Knowing that drawing is a matter of seeing forms as shapes and values rather than preconceived objects is one thing; the next question is, "How do I find correct proportions and place those shapes accurately?" I use three techniques: measuring, seeing negative shapes, and drawing upside down.

Measuring

A sculptor uses calipers to transfer the correct proportions of the model to the block of clay. But I measure with an outstretched arm, which is simply a freehand way of transferring the proportions of my subject onto my paper. (If you are working directly from a photo, you can use marks on a strip of paper rather than the thumb-and-pencil technique described on the opposite page.)

Simplifying by Measuring
Use the thumb-and-pencil measuring technique to help you place the elements of a simple still life, such as this arrangement of a vase and a pomegranate (drawn with HB, 2B, and 4B pencils).

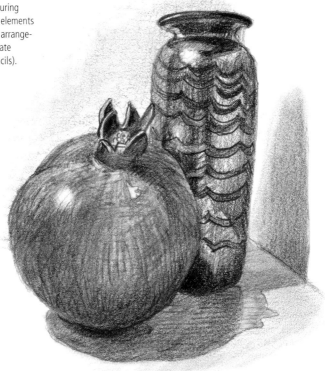

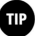 **TIP**

Before I begin measuring, I squint my eyes to see just how simple I can make the subject. This helps me see the basic shapes that make up the composition. To begin this still life, I simplified both objects into one silhouette, in much the same way that I began the fuchsia drawing on page 8.

12

Thumb-and-Pencil Measurements

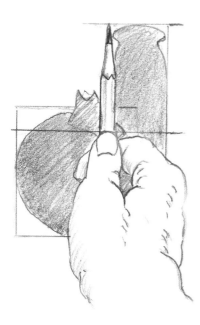

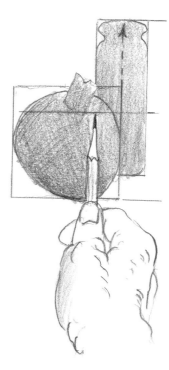

Step 1 Stretching out my arm as far as I can at eye level, I look down my arm toward my setup. I put the point of my pencil at the top of the tallest object and my thumb where I think the center of the arrangement is.

Step 2 Keeping my arm straight and my thumb in place, I lower the pencil point to the part of the setup I identified as the center. If my thumb is now on the bottom of the form, I have found the center. I mark this center point on my paper.

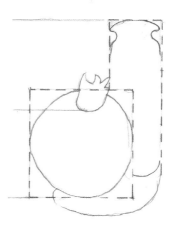

Step 3 Marking the top, middle, and bottom lines, followed by the basic shapes is a good way to lay out the drawing. Sketching lightly with my HB pencil, I make a rectangle for the vase, a square for the pomegranate and an angled rectangle for its stem. I use other "thumb" measurements within the forms to establish their proportions and relationships. The base of the stem sits on the center point I identified in step 2. The distance across the top of the tall rectangle (vase) is approximately one third of its length. A plumb line dropped from the center of the vase marks the right edge of the pomegranate.

Step 4 With my proportions now sorted out, I can carefully sketch the contours of the pomegranate and the vase inside their respective boxes and then erase my construction lines (the boxes). I am now ready to complete the drawing by adding the shadow shapes and shading the images.

Focusing on Negative Shapes

A non-artist can enjoy the graceful "positive shape" of this beautiful cypress tree and go no further. But an artist needs to see and be aware of the space *around* the cypress—the *negative shape*—in order to draw its outer shape. When I begin a drawing, I use negative shapes in conjunction with measurement. Before evaluating the negative shapes, I look for common measurements and make light construction lines, as I did for the still life on pages 12 and 13.

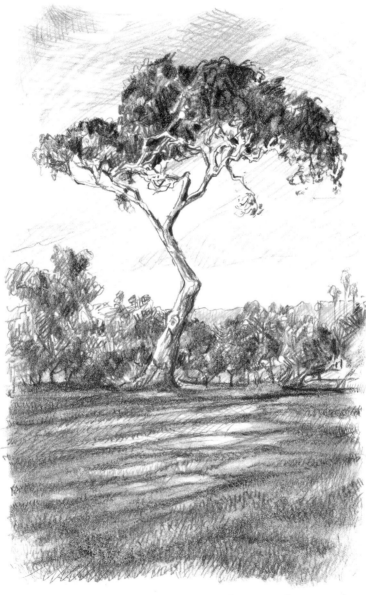

Measuring with the Eye Note that the overall height of the tree is exactly the same as the width of its canopy. This will help you draw the correct proportions when transferring the tree.

▶ **Creating Atmosphere** These are the values I used for this drawing: 9, 7, 4, and 2. There is no value 1 because any black in the distance would destroy the illusion of atmosphere. (See page 44 for more information on atmosphere.)

9	7	4	2

Understanding Freehand Drawing An exercise that will help you understand the essence of freehand drawing is to stand in one place, close one eye, and use a marker to trace the exact lines of your subject onto a rigid, transparent plastic sheet on which you have drawn grid lines. The verticals of the grid act as plumb lines, and the horizontals tell you how high or low one area is in relation to another. If you also draw a grid on your paper, transferring your tracing will be relatively easy. But freehand drawing implies the need to eventually transfer without using a grid. This is where the techniques of measuring and seeing negative shapes come in.

Cropping In After taking measurements to find the height and width of the cypress, I simulate a grid by lightly drawing rectangles and boxes around the canopy, trunk, and distant trees. "Cropping in" like this allows me to see positive-negative shape relationships better and helps me refine my drawing.

Interpreting Space The darkened sky and grass areas represent "negative" space around the trees; drawing the edge of these negative areas creates the "positive" shapes (trees). Conversely, drawing the edge of the positive trees creates the negative shapes (sky and grass).

Drawing Upside Down

Sometimes, when I am building up a drawing, I find that my preconceptions are so strong that it becomes almost impossible to continue drawing shapes and values objectively. The best solution I've found for regaining objectivity is to turn both the image I'm copying and my drawing paper upside down. Seeing the image upside down almost immediately negates the preconceptions of what your subject *should* look like, and you can begin to see the shapes objectively.

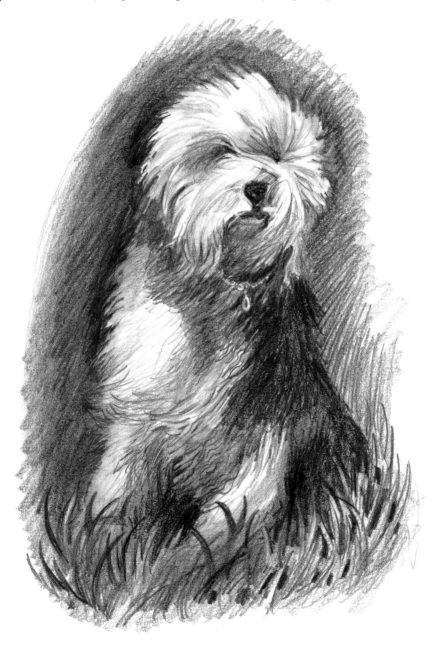

Looking for Shapes This sheepdog is a perfect candidate for you to attempt drawing upside down because it is composed of such simple shapes. Lay in the drawing with an HB, and then use a 2B, 4B, and 6B, respectively, for lights, middle values, and darks.

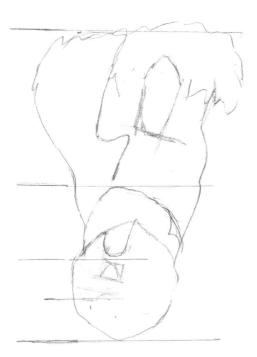

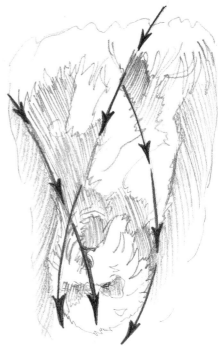

▲ **Step 1** After turning the photo of the dog upside down, I use an HB pencil to lightly sketch the dog on my drawing paper. I use shape identification, measurement, and negative shapes to capture the basic outline. The head is roundish, the neck crescentlike, the back a modified triangle, and the space between the legs a rectangle. I find the halfway mark at the top of the crescentlike shape; then I locate the nose and eyes by dividing this area two more times.

▲ **Step 2** Now that my construction lines are in, I begin to add the dark (positive) shapes. Note how drawing the positive shapes creates the light (negative) shapes. I also take note of the "flow," or movement, in the subject. Follow the arrows I've drawn here, and then look for those flow lines in the final drawing on the opposite page. Flow lines not only help you get better proportions (as negative shapes do), they also convey the overall rhythm in a drawing.

◄ **Step 3** As I slowly refine the edges of both the positive and negative shapes, the sheepdog miraculously begins to appear. But remember, I am drawing abstract shapes, upside down, so I won't know just how accurate my dog really is until I turn it right-side up. Once I am satisfied with the positioning of all the elements, I turn the paper right-side up, and, magically, the dog appears.

TIP Use the two types of strokes shown here for furry textures. A sharpened 4B will provide a dark, hard-edged contrast (left), and a blending stump will help unify the cross-hatching strokes (right).

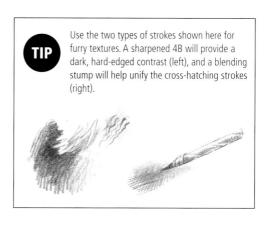

DRAWING VALUES AS SHAPES

This demonstration is a summation of all the shape- and value-seeing tools I have discussed so far. You can attempt copying it either right-side up or upside down. If it looks too difficult, I recommend you try drawing it upside down. Stick with the basics and avoid preconceptions, and you will be amazed at what you can accomplish.

Observing the Subject Before I start drawing, I observe my subject and look for basic shapes and measurements.

Step 1 With an HB pencil, I lightly sketch a vertical line and mark off three equal divisions: hairline to brow, brow to top of lip, and top of lip to bottom of beard. I draw the basic shape of the head and place the nose and lips on the left side of the vertical plumb line; then I sketch in the shapes of the shadows.

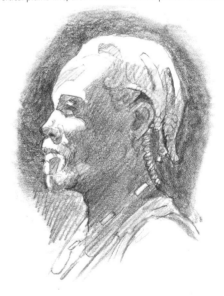

Step 2 I erase the construction lines and carefully shade the shadow shapes with one flat tone. I don't bother with details at this point; instead, I concentrate on shading the light and dark shapes as accurately as possible.

Step 3 This is the stage where I render details and the smallest shapes. Shown in profile, the features are relatively simple and clearly can be seen as light and dark relationships. If I accurately draw these shapes, I can achieve a likeness.

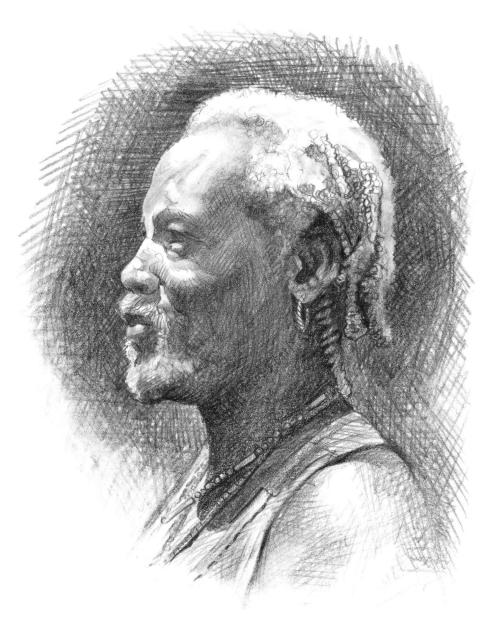

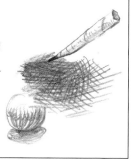
Step 4 I employ various strokes and blends to suggest textures and transitions in value. I primarily use crosshatching to complete the drawing of this head. But these are not just random strokes. If you look at the chin and cheek, you will notice that the stroke directions not only add darkness but also help define the multiple curves of these areas.

DEPICTING FORM

Light and shadow create the illusion of solidity, or form, in drawing. This exercise will help you observe the light and shadow "families," or groups of values, in any composition.

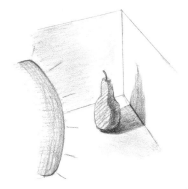

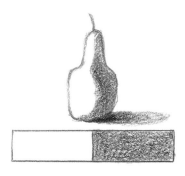

Step 1 Set up your still life box, place a pear or another object in the corner of the box, and shine a spotlight on the side of the object to create a division of light and shadow.

Step 2 Draw the pear with a simple division between light and shadow. The value scale below the pear demonstrates this division.

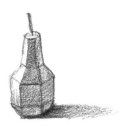

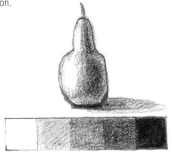

Step 3 Now look for planes. Any planes that are mostly illuminated by the direct light are part of the light family. Planes facing away from the light—including the cast shadow—are part of the shadow family. Make another sketch of the pear, showing each plane, and shade only the planes in the shadow family.

Step 4 Draw the pear again, but this time use a range of values. By adding subtle halftones between the extremes of light and dark, you can create a feeling of solid roundness.

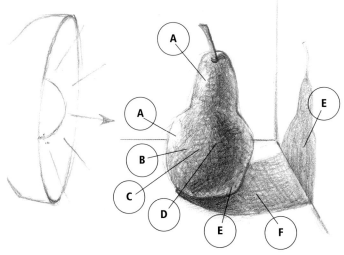

Understanding Terms This illustration shows the terms used to describe the lights and shadows that create form. The very light areas, A, are *highlights* (which are fairly subtle on a pear). B is a *light* area surrounding the highlights. C is a *halftone;* it forms the important visual transition between light and shadow. D is the *shadow core,* or the area where light ceases and shadow begins. E is *reflected light,* both on the wall (within the cast shadow) and on the object (along the core shadow). Without the contrast provided by reflected light on the dark side of the pear, there would be no shadow core—only shadow. F is the *cast shadow,* which begins dark and hard-edged and grows lighter and less distinct as it recedes from the light source and object.

Directing the Eye with Value Edges

Value edges, or the lines where contrasting values meet, play an important role in directing the eye around a drawing and holding the viewer's attention.

▶ **Establishing a Focal Point** When value contrast is high and hard edges dominate one area, the viewer's eye will be directed to that area. This area is called the "focal point," and it should also be the center of interest.

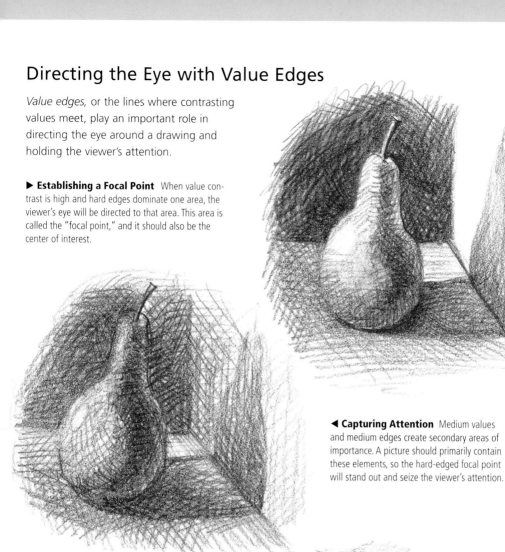

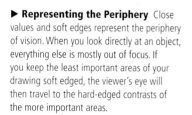

◀ **Capturing Attention** Medium values and medium edges create secondary areas of importance. A picture should primarily contain these elements, so the hard-edged focal point will stand out and seize the viewer's attention.

▶ **Representing the Periphery** Close values and soft edges represent the periphery of vision. When you look directly at an object, everything else is mostly out of focus. If you keep the least important areas of your drawing soft edged, the viewer's eye will then travel to the hard-edged contrasts of the more important areas.

ARRANGING VALUES

Now that you understand the importance of learning to see your subject as a series of dark and light shapes rather than as an identifiable "thing" with a label, let's experiment with setting up a composition using a still life box. (See page 4 for a description of how to construct a still life box.) As an example, I have set up a still life using a light, a medium, and a dark object to show how a setup with balanced values is affected by three very different backgrounds.

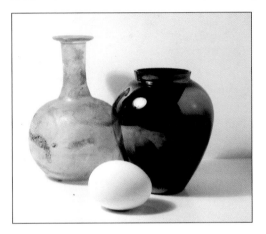

◀ **Light Background** With white making up all of the negative space (the walls and floor), the edges of all three objects are very sharp, except where the white egg meets the white floor. Note how the light becomes slightly darker on the right as it gets farther from its spotlight source. This is characteristic of artificial light. (See page 27 for more on artificial light sources.)

▶ **Light/Dark Background** Now I add a piece of black mat board to the walls of the box, leaving the floor white. What a difference! The dark edges of the black vase are now lost, and the cast shadows appear darker because there is less ambient light bouncing into them. (A photographic note: By exposing for such a bright white on the base, the subtle core shadow on the egg becomes washed out.)

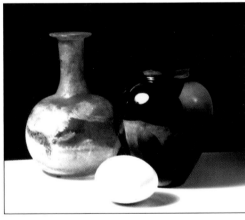

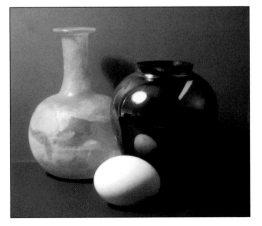

◀ **Uniformly Dark Background** For this setup, I cover the two walls of the box with a nearly middle-value gray and the bottom of the box with a black mat board. The bottom appears to be dark gray rather than black because the bright spotlight lightens it. Notice how the reflection in the black vase is nearly absent now (except for a little light from an overhead fluorescent lamp), and the values of all three objects appear more subtle.

Drawing a Simple Still Life

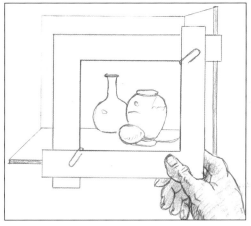

Setting Up a Still Life To start this exercise, either arrange your own still life or copy my setup, and place the objects in the still life box. Position your light source above and to one side of the box. (We will cover more about light sources on the following pages.)

Selecting a Composition After choosing a light background for my drawing, I create a viewfinder (see "Making a Viewfinder" below) to help me determine the best format. When I like what I see, I lightly sketch the composition onto my paper, using the measuring techniques described on page 13.

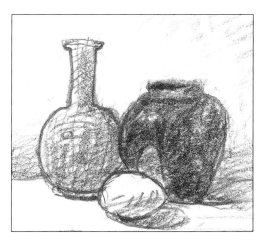

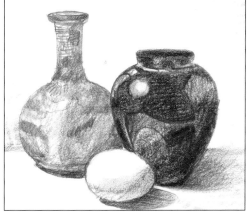

Creating Thumbnails Before continuing with my drawing, I make a few small, quick, rough sketches on scrap paper to test out the values in my composition. These *thumbnail* studies help me decide what values will work best for my final drawing.

Building Up Correct Values Returning to my paper, I use sidestrokes, crosshatching, a stump, and a kneaded eraser to build up the desired values. To get very light, textured values, I lightly smudge an area and then lift out lights with my kneaded eraser.

Making a Viewfinder

Use two L-shaped pieces of cardboard (paper-clipped together; see illustration above) as you would a viewfinder on a camera to help find the best arrangement for your composition. Look through the frame; move it closer and farther away, or rotate it until you find the most pleasing view.

ESTABLISHING A LIGHT SOURCE

Most indoor situations have too many light sources to make a good drawing from life. Ambient light from windows, lamps, open doors, and so on produces conflicting highlights and makes it difficult to show solidity. A single, controlled light source works best.

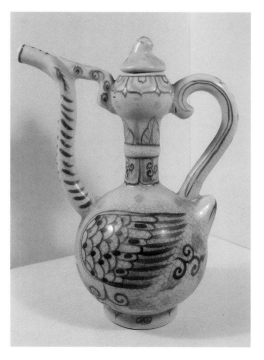

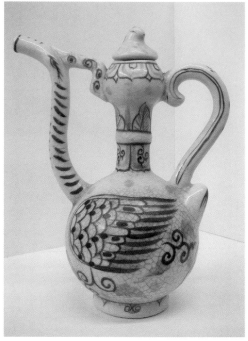

Double Lighting (above) Two opposing incandescent sources light this Asian teapot, creating two highlights and two vague shadows. Compare this photo to the solidity of the form on pages 20 and 21. The double lighting makes the teapot look flat.

Fluorescent Lighting (above right) Because they come from a long-wave light source, fluorescent lights tend to diffuse and soften forms. Here, the teapot is set in the same place as in the first photo, but now all the light is coming from eight-foot fluorescent bulbs above. As with other multiple light sources, the result is that the teapot still appears too flat to make an interesting drawing.

Single Lighting (right) In this version, I add an apple and a pear for variety of shapes, values, and surface types. I light the setup from the right and slightly above. The pot and apple are fairly glossy, so their highlights are bright, but the pear has a matte surface, which diffuses its highlight. Compared to the first two setups, the light, shadows, and cast shadows in this setup not only add a sense of volume but also create an interesting design.

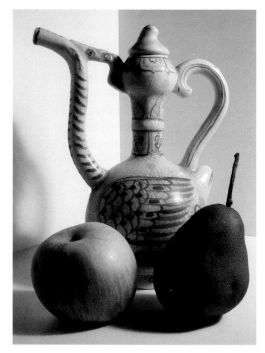

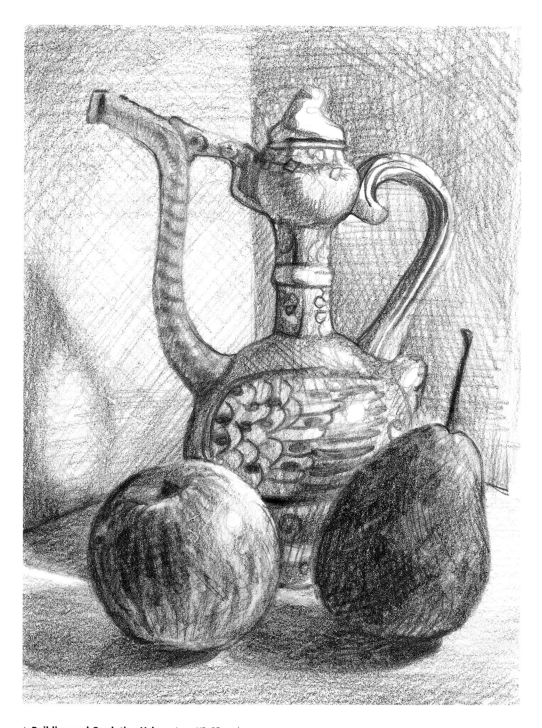

▲ Building and Gradating Values I use HB, 2B, and 4B pencils and a single light source for this rendering of the composition at left. I employ crosshatching to build up values, and I use underhand sidestrokes for gradated areas.

▶ Value Scale This drawing makes use of values 8, 5, and 2.

8 5 2

WORKING WITH NATURAL LIGHT

The two sources of natural light are the sun and the moon. In addition to the fact that natural light maintains its strength with distance (whereas light from artificial sources weakens with distance), natural light has other distinct characteristics, which you'll discover over the next two pages.

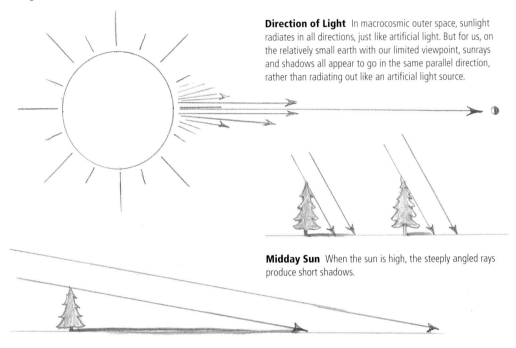

Direction of Light In macrocosmic outer space, sunlight radiates in all directions, just like artificial light. But for us, on the relatively small earth with our limited viewpoint, sunrays and shadows all appear to go in the same parallel direction, rather than radiating out like an artificial light source.

Midday Sun When the sun is high, the steeply angled rays produce short shadows.

Morning and Evening Sun When the sun is low, rays are more horizontal, creating long, parallel shadows.

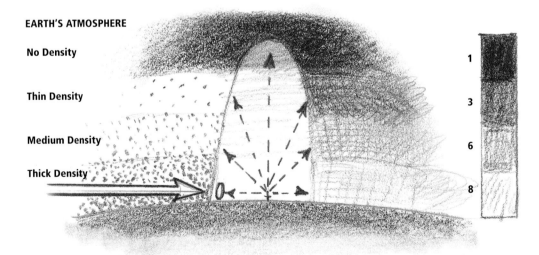

EARTH'S ATMOSPHERE

No Density

Thin Density

Medium Density

Thick Density

1

3

6

8

Reflectiveness of the Atmosphere In terms of atmospheric values, outer space is value 1—black—because there is nothing in it (except widely separated stars and planets) to reflect sunlight into our eyes. As we descend toward earth, the atmosphere becomes filled with more and more dust, water, and other particles, and it reflects more and more light. This makes the air appear lighter on the horizon and darker as we raise our eyes upward. This bell-shaped diagram and inverted value scale show how the sky at the horizon appears lighter and gradually darkens as we gaze toward infinite outer space.

WORKING WITH ARTIFICIAL LIGHT

Artificial light is defined as any light source other than the sun or moon. This can include incandescent light sources (such as ordinary lightbulbs), fluorescent lights, candles, and firelight. The main characteristic of light coming from an artificial source is that it weakens as it leaves its origin.

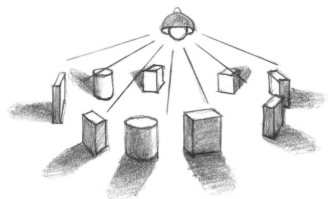

Shadows Cast by Lightbulbs
This simple diagram shows how an artificial light source casts shadows in all directions. Note how the cast shadows get lighter and fuzzier as they extend out. This is typical of shadows created by artificial light. Shadows cast by fluorescent light are fuzzier than those thrown by incandescent light.

Shadows Cast by Candles and Firelight Candles and firelight cast soft, flickering light and shadows. Notice how the light gets weaker as it gets farther from the flame. The cast shadows also grow weaker as they soften and blend into the surrounding darkness.

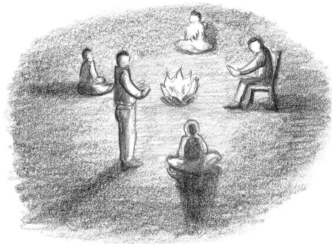

Directional Effects These two sketches show the same face with light coming from two different directions. We are most familiar with the way things appear when they are lighted from above, as in the drawing at left. However, when the light comes from below—say from a candle, a campfire, or a flashlight—unfamiliar light and shadow shapes are created, and the same person looks startlingly different.

EXPLORING PERSPECTIVE IN SHADOWS

Shadows cast by natural light (such as the sun) and those cast by artificial light (such as a lamppost) obey different rules of perspective. Practice depicting shadows by following the demonstrations on these two pages.

Showing Shadows Cast by Natural Light

Because the sun is so far away from us, the individual light rays it casts appear to be parallel. For this reason, these light rays obey the rules of perspective governing parallel lines, referred to as "linear perspective." The rules of linear perspective dictate that all the receding lines in a drawing or painting converge at one, two, or three vanishing points, even though they are invisible beyond the objects they define. Draw a simple landscape with a house and use the sun as your light source (and vanishing point).

Step 1 Draw a dashed horizon line and pick a point above the line for the sun's location (A). Drop a vertical line from A to the horizon line to locate one vanishing point (B). Use point B and another vanishing point on the horizon line to construct a simple house as shown below, starting with the vertical corner line. (There are two vanishing points because the object is viewed from an angle, and there is more than one plane.) Draw a straight line from A through the left upper corner of the house and to the ground. Draw another line through the right upper corner of the house. Extend the line from point B along the bottom right side of the house, and draw another line through the bottom left corner. The points where the lines intersect (C and D) indicate the limits of the shadow cast by the house. Draw a line from C to D to show the end of the shadow.

Step 2 Now copy the construction shown here. Add the doors, windows, extended eve, chimneys, trees, shrubs, and mountains. To place the shadow correctly, use the perspective lines from the sun as you drew in step 1, then adjust to make the shadow follow the contours of the landscape.

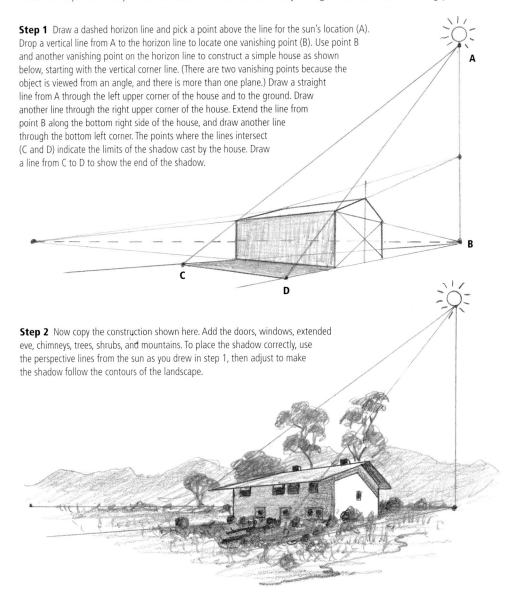

Showing Shadows Cast by Artificial Light

The height and angle of a light source determine the length of a shadow; a tall lamppost makes short shadows, whereas a lower light (like the one on the opposite page) makes longer shadows. The drawings below also demonstrate how shadows from an artificial light source radiate in all directions. Try reconstructing this drawing to better understand shadow perspective.

Step 1 Draw a tall lamppost.

Step 2 Construct an array of three-dimensional boxes around the lamppost. First draw some vertical rectangles, and then use the horizontal line vanishing point (HLVP) on the horizon line (AB) to draw the sides and tops of the boxes.

Step 3 Drop a plumb line from the light source (L) down to a horizontal line at the base of the post (CD). This point is the shadow vanishing point (SVP).

Step 4 Draw light lines from the SVP through the bottom corners of each box. Then draw additional light lines from L through the top corners of each box. Draw a horizontal line where the lines from SVP and L meet—this is where the shadow cast by the object ends. The shadows will radiate from the SVP like the spokes of a wheel from its hub. For more information on the rules of perspective, see *Perspective* (AL13) in Walter Foster's Artist's Library series.

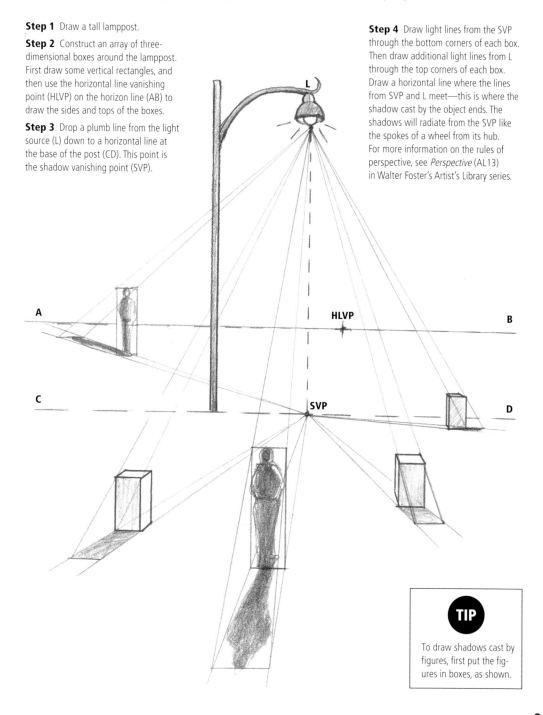

TIP

To draw shadows cast by figures, first put the figures in boxes, as shown.

EXPRESSING ILLUMINATION

In nature it is easy to know when we are in bright or dim illumination: We simply look at the world around us. Likewise, in a drawing, we gain knowledge of illumination through the values of the objects and the general lightness or darkness of the background.

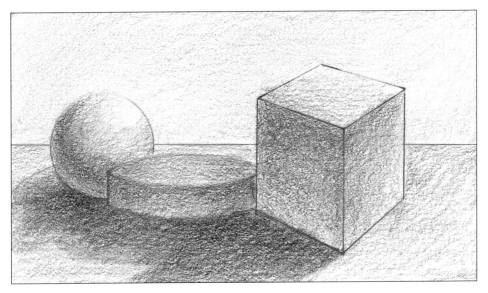

Bright Illumination In this diagram, most of the images contain fairly light values. The lightness in both the background and foreground implies bright illumination.

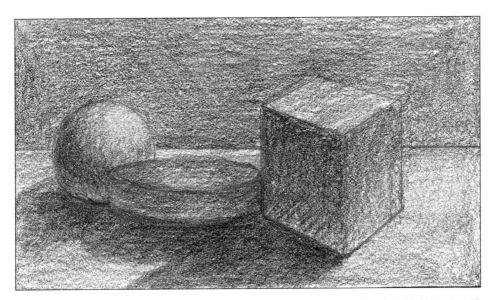

Dim Illumination Using exactly the same objects and light source, the values are now darkened. The blackish and grayish values of the major field imply dim illumination.

CREATING LUMINOSITY

There are three rules for effectively portraying luminosity: (1) Luminous areas must be relatively small in size; (2) luminous areas must be lighter in value than their surroundings; and (3) extremely dark values must be avoided (black should lose its harshness and appear deep gray and atmospheric).

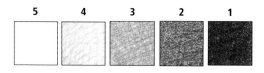

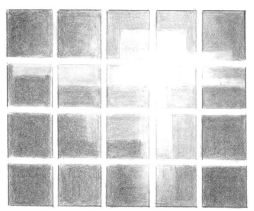

▲ **A Traditional Five-Value Scale** This five-value scale runs from white through middle values to black. In the drawing below, I used every value except for 1.

▶ **A "Pixelated" Grid** Here I have simplified the drawing below by squaring off the values and breaking the image into separate boxes, or "pixels." Study this grid to see how luminosity is carried softly through atmospheric darks without using the darkest value, number 1.

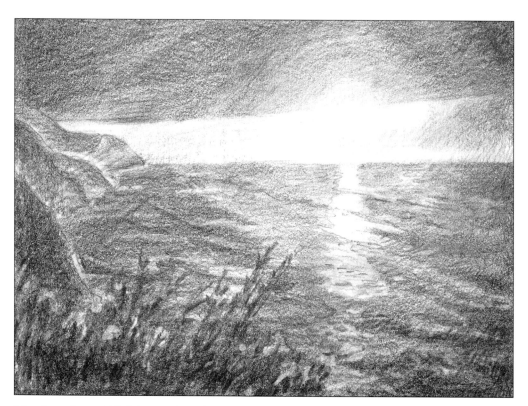

A Luminous Sunset With dark, atmospheric values surrounding a relatively small core of light, this sunset has an appealing, luminous quality.

REINTERPRETING VALUES

When an amateur photographer points a camera at a bright sky or glaring ocean and clicks, the darks in the resulting image can end up too dark, and the lights are often washed out. The optimum exposure for a camera—and for the human eye— is middle-value gray. An artist must understand this phenomenon when working from a photo and attempt to correct the values accordingly.

Adapting from a Photo Compare this photo with my drawing below, and note how the readjusted values in the drawing add more balance and atmosphere. I employ a full range of values, but the darkest darks serve solely as accents in the tree and the human figure.

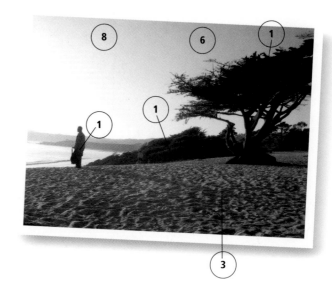

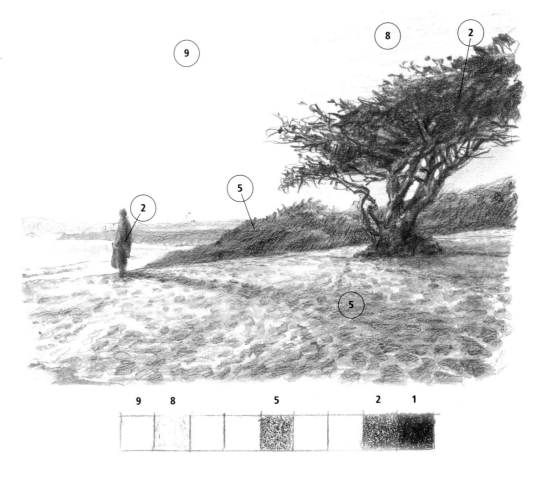

32

Adjusting Value "Keys"

Like a pianist, an artist can choose any "key" and play in it. A virtuoso musician knows how to use different keys to evoke different emotions. Similarly, by using value variations, artists can convey a range of moods, from bright and cheery to dark and somber, or even portray weather conditions and times of day. Think of a value scale as a piano keyboard, with each group of numbered values representing a different key.

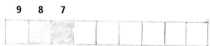

High Key When you keep your values on the upper (lighter) side of the scale, the effect will be that of a foggy morning. It could also evoke a dreamy, pensive feeling from the viewer. This drawing makes use of values 9, 8, and 7.

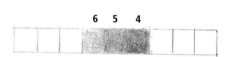

Middle Key Limiting yourself to the middle part of the scale creates the look of a cloudy day. These middle values can create a calm, soothing atmosphere. This drawing makes use of values 6, 5, and 4.

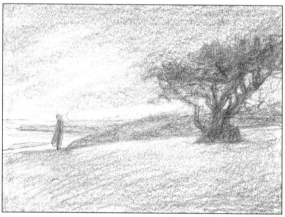

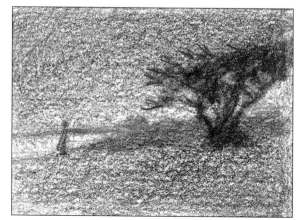

Low Key The lower (darker) part of the scale is perfect for depicting dusk, dawn, or a stormy day. Emotions elicited from this drawing could range from peaceful and tranquil to passionate and turbulent, depending on the intensity of the darks. This drawing makes use of values 3, 2, and 1.

DISTRIBUTING LIGHT INTENSITY

One of the reasons most artists use either a single light source or direct sunlight is to avoid the flat lighting that results from multiple artificial lights or a cloudy day. Flat lighting on an object is like a flat conversation: It is boring and pointless and does not allow the listener to focus on the part of your statement that you consider most important.

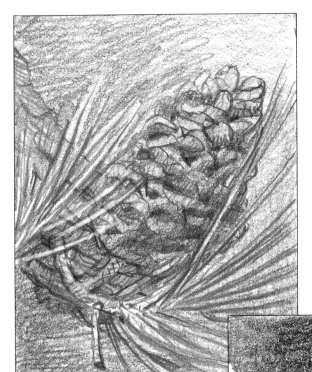

Poor Lighting Compare this flatly lit pinecone with the others on this and the opposite page. With no contrast, the composition lacks a focal point. There is nothing to direct the eye or interest the viewer.

Better Lighting Bathed in direct sunlight, the pinecone immediately becomes more interesting, because there is more contrast between dark and light values. But there still is no focal point. The viewer's eye is pulled equally to the dark upper area, the sunlit pinecone, and the middle value in the bottom third of the composition. If the light focused more on the areas important to the composition, this drawing would become more interesting.

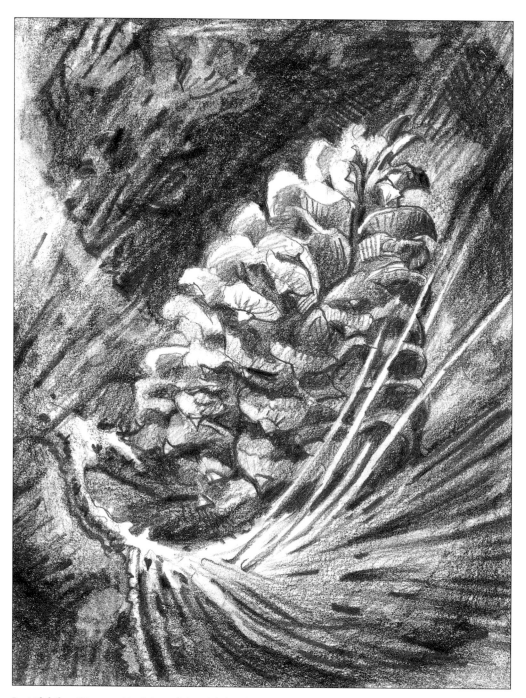

Best Lighting This composition balances light and dark nicely. With the addition of darks, the pinecone and pine needles appear lighter and more dramatic. The pinecone and needles are now the most interesting parts of this drawing. I use a kneaded eraser and an erasing shield to lighten the branches and some of the related textures. These secondary focal points keep the viewer's eye circulating around the composition.

USING CONTRAST TO ATTRACT THE EYE

In a successful conversation, we make our point by getting right to it and stating it clearly. Drawing is the same in this respect. By placing your center of interest (or focal point) carefully and giving it the greatest amount of contrast, you can create visual interest and draw in the viewer's eye. The point of highest contrast immediately captures the viewer's attention.

Study these drawings and diagrams to learn how to use contrast and value placement to create both a focal point and a path for the eye to follow.

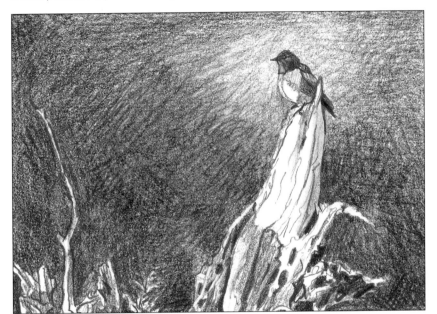

Creating a Focal Point
The viewer's eye immediately goes to the tree trunk and perched bird in this composition because they hold the greatest contrast to the medium-dark background. Notice how I've kept the background a touch lighter behind the bird to better set off the darks.

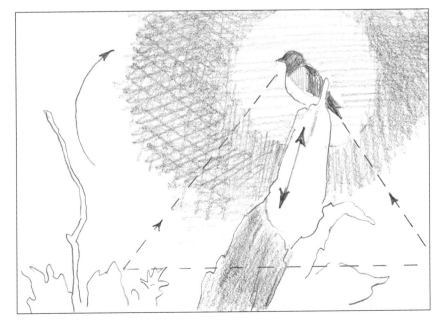

Circulating the Eye The viewer's eye travels up the thick branch to the high-contrast bird at the apex of a stabilizing triangle. Secondarily, the light branch at far left attracts the eye and holds it, and then circulates the eye back to the bird.

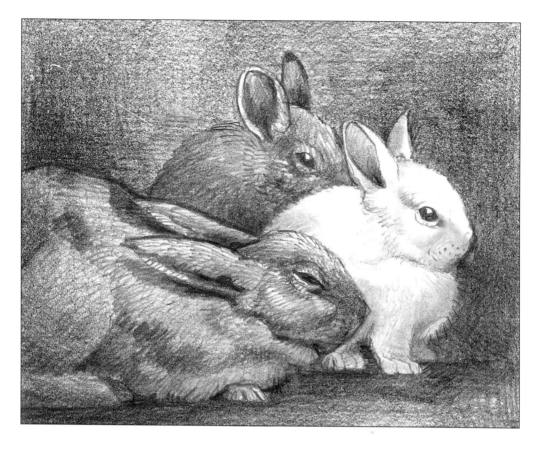

▲ Centering Interest
By blending the darker rabbits into the background of this drawing, the contrasting white rabbit becomes the center of interest.

▶ Directing Attention
The white rabbit's black eye is like a visual magnet; then the beady eyes of the darker rabbits attract the viewer's attention and create a triangular flow between the three rabbits.

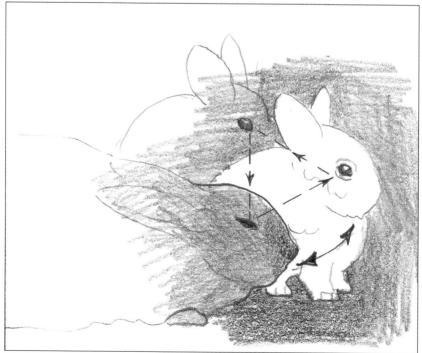

MOVING THE EYE THROUGH THE ART

The eye will normally enter a drawing where the largest positive shape touches the border. If such a shape does not touch the border, the eye will jump inside the composition to the most interesting positive element. From this point on, it is the artist's sense of design that will direct the viewer's eye. The eye follows paths created by (1) edges of light and dark; (2) the bulk of light or dark areas; and (3) light or dark dots, dashes, and accents. (For more information, see *Dynamic Composition* in Walter Foster's Drawing Made Easy series.)

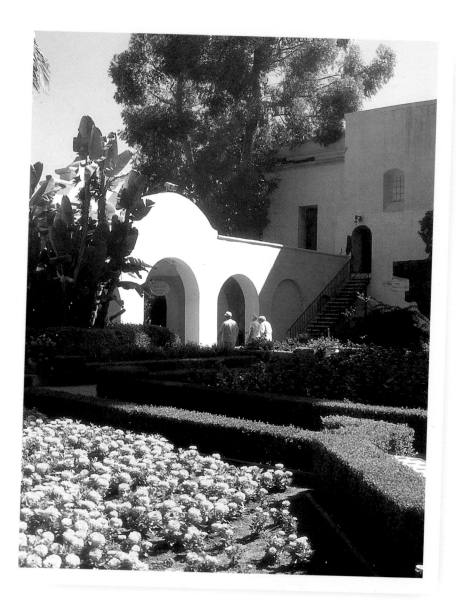

Attracting and Directing Attention In this photograph of California mission-style buildings and their surrounding gardens, light guides the viewer's eye into and through the scene. Lines, dots, and accents add interest.

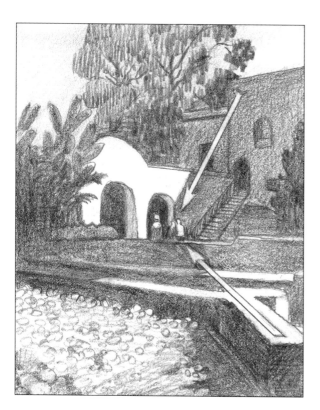

Drawing Attention Look at the photo on the opposite page, and then follow the arrows in this diagram. Note that the eye enters where the foreground hedge touches a border and then moves through the shadow to the people, who act as accents. Speaking of interest, cover up the flowers with your hand, and see how much sparkle the picture would lose if they were eliminated.

Maintaining Interest Have you ever looked at a long, blank wall or an empty sky? Think of how your eye begs for something solid to focus on. It cannot stay in one place for very long. Like a playful kitten fascinated by a rolling ball of yarn, the eye is attracted to accents of light and edges. Without these, the eye will simply become bored and move on to someone else's drawing. Once again look at the photo; analyze how your eye moves within it, and see if the arrows in this diagram are similar to the paths your eye follows.

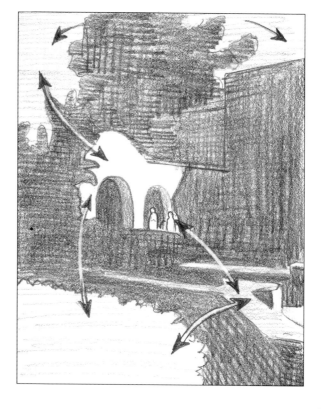

CREATING DEPTH

Linear perspective lends the illusion of dimension to a composition, but an artist has additional tools: overlapping objects, creating contrasts in value and texture, using aerial perspective, and introducing shadows.

Using Shapes, Values, and Textures

The way you place values in the foreground, middle ground, and background affects the perception of depth in a drawing. Contrasting these values and their textures conveys a sense of dimension.

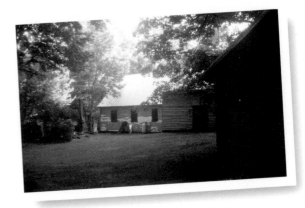

▶ **Adjusting References** In my photo at right, the foreground came out too dark because the camera's exposure was adjusted for the bright sky in the background. To create a more balanced composition, I use this photo to create two thumbnail sketches (below), each with a different value arrangement from which to choose.

◀ **Overlapping Shapes** Overlapping is an excellent way to create the appearance of depth. The addition of aerial perspective (see page 44) increases the illusion further. Although the composition shows depth, it still lacks interest because it remains overly true to the photograph. The composition also is unbalanced with the dark right side drawing the viewer's eye.

▶ **Balancing Value Contrasts** Starting again, I use the same value structure as I did for the first thumbnail. However, I lighten the foreground shed, add a door and a window, draw some branches in front to push back the shed, and add lighter grass in front of the distant building to create a balance of value contrasts throughout. I find this thumbnail more interesting, so I will use it in conjunction with the photo as the basis of my final rendering.

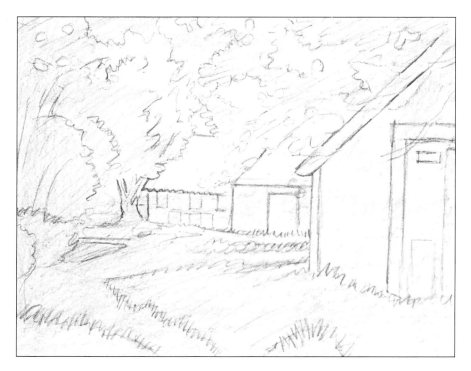

Step 1 Sketching lightly with an HB pencil and using primarily straight lines, I mark out the foreground shed with the new details, two distant buildings, diagonals on the ground, and general areas of foliage.

Step 2 Now I transform the light, straight lines into more specific shapes and details. Using a softer 2B pencil, I darken the contour lines and apply a flat tone over the entire composition, except for the light areas in the sky and the roof of the background building.

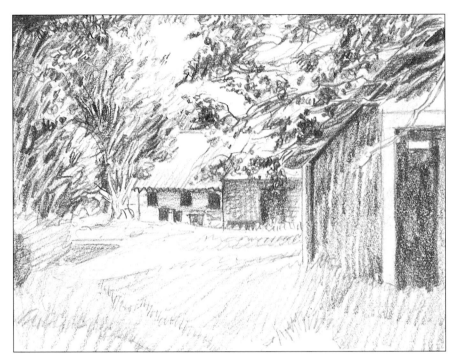

Step 3 In order to set the range of my value scale, I use a 4B pencil to darken the windows, the shed door, and some of the branches and leaves. This tells me where to place my middle values, as the lights and darks already are established.

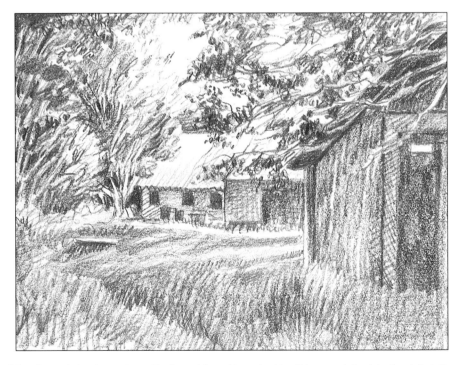

Step 4 I continue to darken the meadow and its diagonal lines with crosshatching. Using an underhand shading stroke in the trees, I darken the largest areas with blending strokes. This brings out the light, which I can further accentuate with a kneaded eraser.

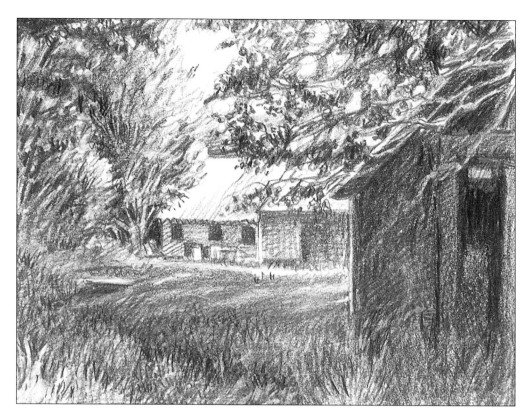

Step 5 To complete the rendering, I bring out the lighter and darker values to emphasize the focal point and imbue it with an intimate, inviting atmosphere. Note how the detailed textures and dark values in the foreground push the lighter distant structures into the background. This is an example of aerial perspective (see page 44).

Contrasting Textures

This is a sampling of the various strokes I use to build textural interest in this drawing: On the left and right sides, I darken around light areas and then blend over parts to make branches (A). Light cross-hatching on the distant building (B) and heavier crosshatching on the middle structure (C) enhance the perspective in the rendering. I employ medium lines (D), long lines (E), and grassy texture (F) to lend interest to the foreground vegetation. Dark, blended strokes (G) and dots (H) work well for the trees in the background. For the near shed, I use dark crosshatching (I) and heavy dark strokes (J). (See "Basic Strokes" on page 6 for additional textures.)

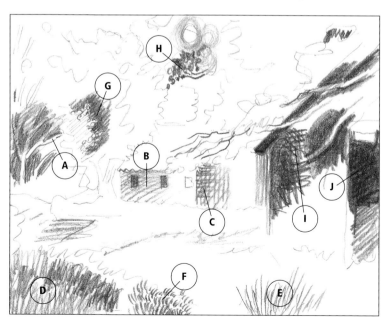

Employing Aerial Perspective and Shadows

In nature, impurities in the air (such as moisture and dust) block out some rays of sunlight, making objects in the distance appear less distinct than objects in the foreground. This phenomenon is referred to as "aerial perspective," and it creates the illusion of depth. In this quiet scene, I take advantage of both aerial perspective and foreground shadows give my drawing dimension.

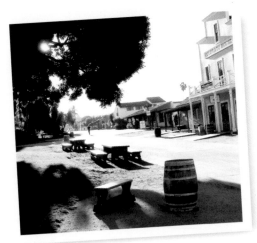

◄ **Choosing a Scene** This location is more interesting in the summer when long shadows come from the side, but the only photo I have was shot in winter with the sun coming in from the south. My solution? I simply shift the direction of the shadows by modifying the composition to match my summer memory. Despite the limitations of the photo, I still can use it to reference when building an appealing composition.

▶ **Thumbnail Sketch** Before starting the actual rendering, I draw a thumbnail sketch. After I block in the basic shapes, I lay in the new, summer shadow areas. My intention is to lead the viewer's eye into the scene by establishing dark, contrasting shadows across the foreground. This thumbnail is now my value guide; the photo is only a reference for the shapes and details.

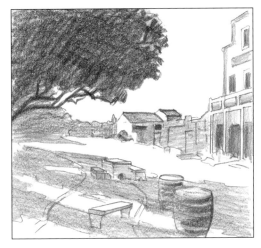

◄ **Rough Value Study** Now I shade in the three main values I intend to use: The tree is the darkest value, the shadows and background are middle values, and the rest is light. This is not a final, detailed value study—just a rough guide for me to recognize the light and dark families as I proceed toward the final rendering shown on page 47.

9	5	2

▶ **Value Scale** I use values 9, 5, and 2 in this drawing.

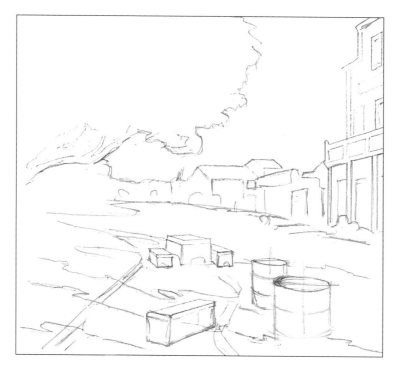

Step 1 Using an HB pencil, I lightly block in the general composition, paying special attention to the perspective on the benches, table, and barrels. These shapes, if drawn correctly, will give an indication of the artist's eye level, which is slightly above them.

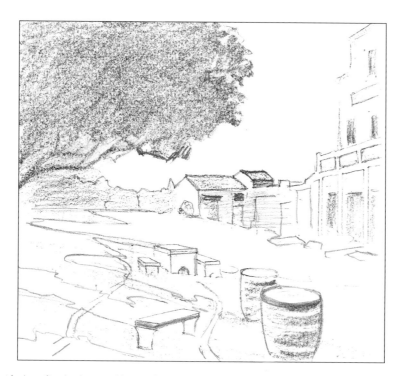

Step 2 Now I further refine the shapes and begin to lay in darker values with underhand strokes. I do not get as dark as the value study yet because I still need to be sure that the shapes of the foreground shadows are placed correctly.

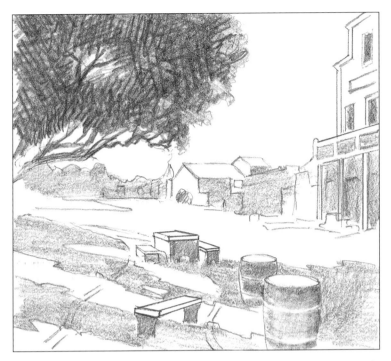

Step 3 At this point, I am certain that these are the shapes I will retain for the final drawing, so I take out my softer 2B and 4B pencils and carefully refine the areas of value. Now the darkest shadows are about as dark as the value study, and now I can focus on adding textures while maintaining the correct values.

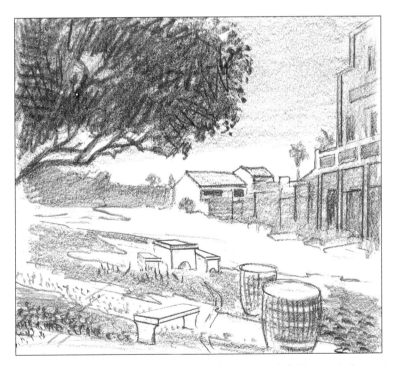

Step 4 At this stage, I begin to experiment with various textures, but I do not completely finish any particular area. I add details such as palm trees in the background, the gradated sky, and the dark windows and doorways.

Adding Textures Here are the strokes I use to finish the drawing: I darken the tree with 4B and 6B pencils, combining sidestrokes and cross-hatching (A). For the sky, I combine sidestrokes, linear strokes, and some erasing to lift out lighter streaks (B). For the background, I use sidestrokes and an eraser (C). For the grassy area in the foreground, I use sidestrokes and grassy strokes (D). I darken the barrel with sidestrokes and linear, vertical strokes (E). The dirt is—appropriately—dirt texture (F). (See "Basic Strokes" on page 6 for additional textures and strokes.)

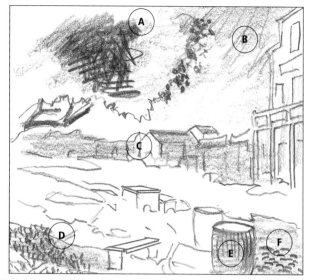

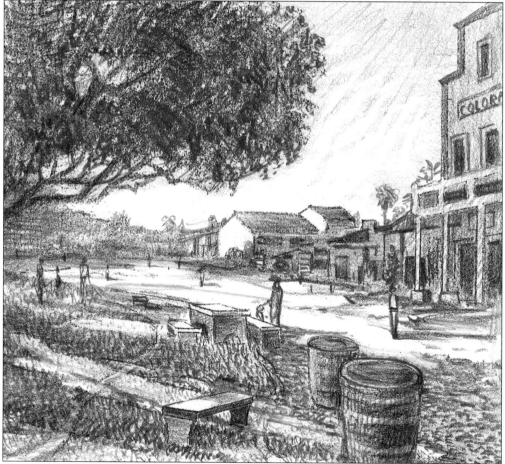

Step 5 I complete the drawing by adding value and texture. The addition of larger figures in the middle ground and smaller figures in the background helps create depth. Note how I've employed aerial perspective by giving the objects in the foreground the most detail. The darker foreground shadows add to the illusion of depth by contrasting the lighter middle ground and background.

CAPTURING LIGHT ON BLACK-AND-WHITE

On page 8 we discussed the phenomenon of simultaneous contrast—where a middle value looks darker on white than it does on black. We also explored the strength of black-and-white images in conveying shape, as well as the way that adding an extra value or two transforms a flat shape into a three-dimensional form. But how does an artist show volume on black? This photograph of a zebra's head offers a perfect opportunity to show the thought process involved in solving this problem.

Working with Strong Contrasts This subject presents a challenge in depicting the contrast between black and white without flattening the shape of the zebra's head.

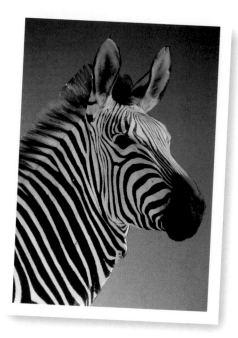

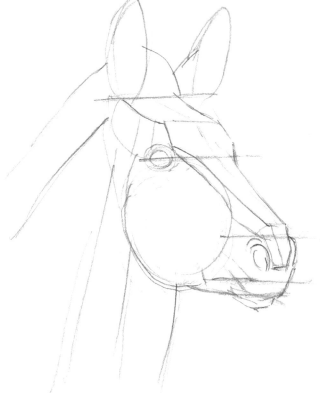

Step 1 Drawing lightly with an HB pencil and using straight lines as much as possible, I carefully delineate the top plane, side planes, and anatomical landmarks. I freely use construction marks to line up the ears, eyes, and nostrils. Simplifying the underlying blocklike shapes will ultimately determine the values of the black stripes.

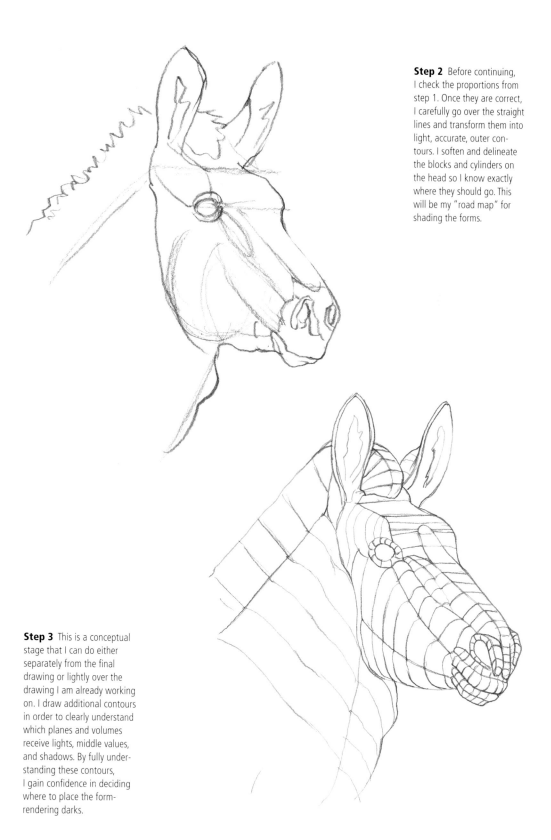

Step 2 Before continuing, I check the proportions from step 1. Once they are correct, I carefully go over the straight lines and transform them into light, accurate, outer contours. I soften and delineate the blocks and cylinders on the head so I know exactly where they should go. This will be my "road map" for shading the forms.

Step 3 This is a conceptual stage that I can do either separately from the final drawing or lightly over the drawing I am already working on. I draw additional contours in order to clearly understand which planes and volumes receive lights, middle values, and shadows. By fully understanding these contours, I gain confidence in deciding where to place the form-rendering darks.

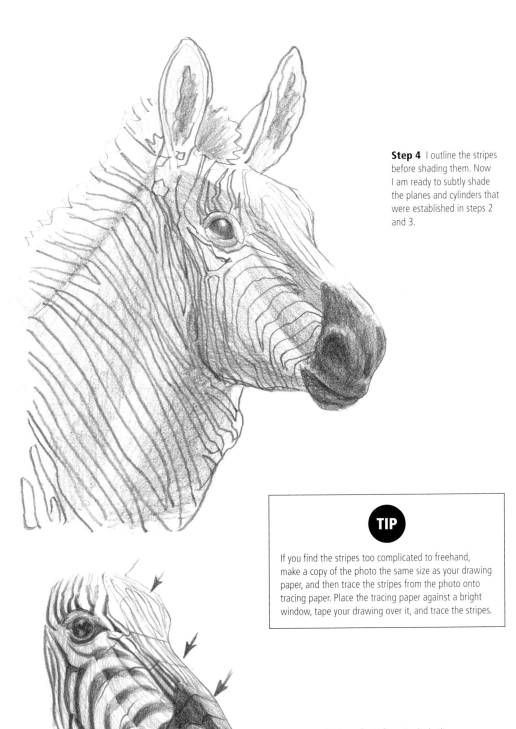

Step 4 I outline the stripes before shading them. Now I am ready to subtly shade the planes and cylinders that were established in steps 2 and 3.

TIP

If you find the stripes too complicated to freehand, make a copy of the photo the same size as your drawing paper, and then trace the stripes from the photo onto tracing paper. Place the tracing paper against a bright window, tape your drawing over it, and trace the stripes.

Capturing Variations in Value Study the lines, contours, and arrows in this drawing. A bright source of light bleaches out the dark stripes that face upward toward the light; those same stripes darken in value as they curve away from the light. Also note how reflected light bounces back up to the underside of the head. By capturing these variations in value, you convey the underlying form of your subject.

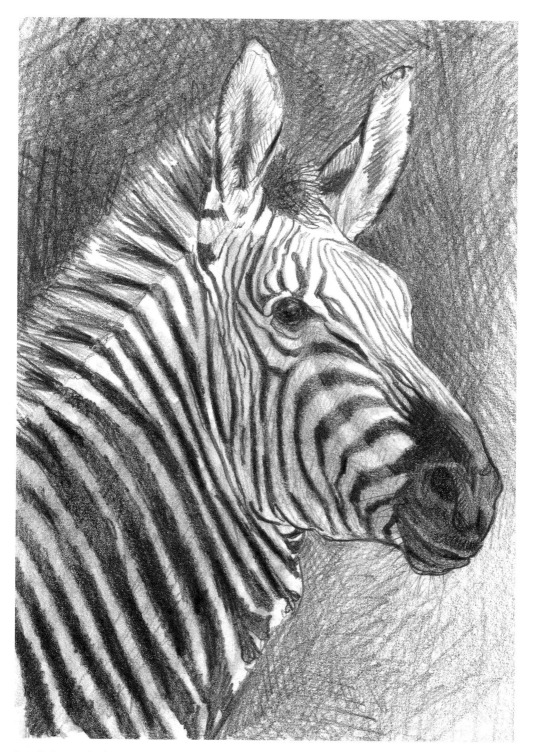

Step 5 Compare this drawing to step 3 and the detail on the opposite page. The important correlation between the drawing above and the other two is the way the changing value on the black stripes in this drawing reveals the structure that was rendered with contour lines in the others. Artists call this principle "local value": As light and shadow hit the forms and the black stripes overlaying them, the black stripes appear lighter or darker. This consistency in change of value reveals form, rather than flattening it.

LEARNING BY COPYING THE MASTERS

There is no better way to study the correct use of lights and darks than by copying a master artist you admire. I used oil paints to copy Jean François Millet's canvas *Woman Sewing by Lamplight,* and later I made a pencil drawing from my painting. Over the next few pages, I will demonstrate the steps in developing the drawing and the lessons you can learn from it about values, shapes, and focal points.

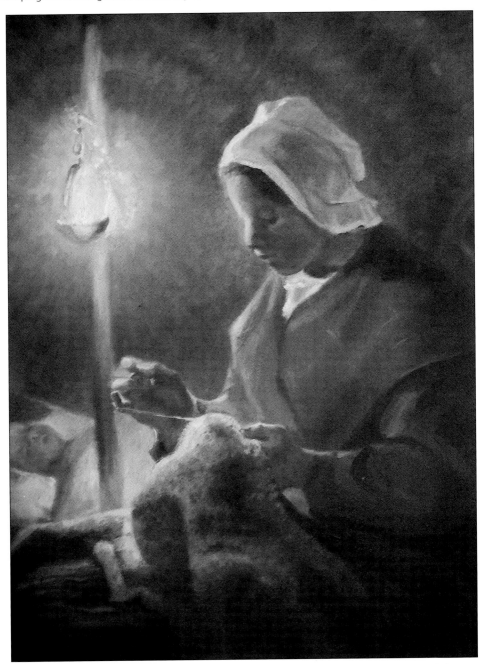

Reproducing a Masterpiece This is my oil painting, *Woman Sewing by Lamplight* (after Jean François Millet). I have reproduced my painting here in black-and-white to make it easier to see the light and dark values.

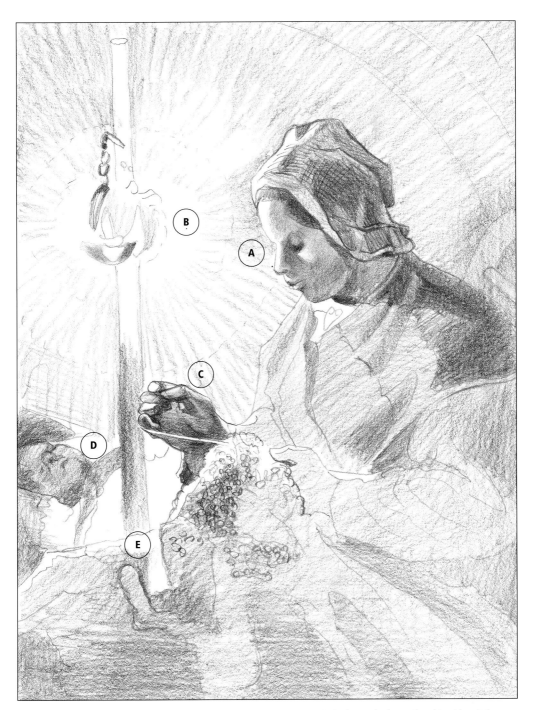

Placing Values Millet, a master of value placement, did not add any lights or darks that might detract from his subject. Before looking at the diagram on this page, study the painting on the opposite page and pay attention to where your eye enters the composition and how it moves around. See if your eye chose the same areas of interest as mine did. Using letters from A to E, I chose A—the woman's gaze—as the main center of interest and B—the lamplight—as a secondary focal point. Letters C to E complete the "story" in descending order of importance. The visual journey from area to area illustrates the title of Millet's painting perfectly.

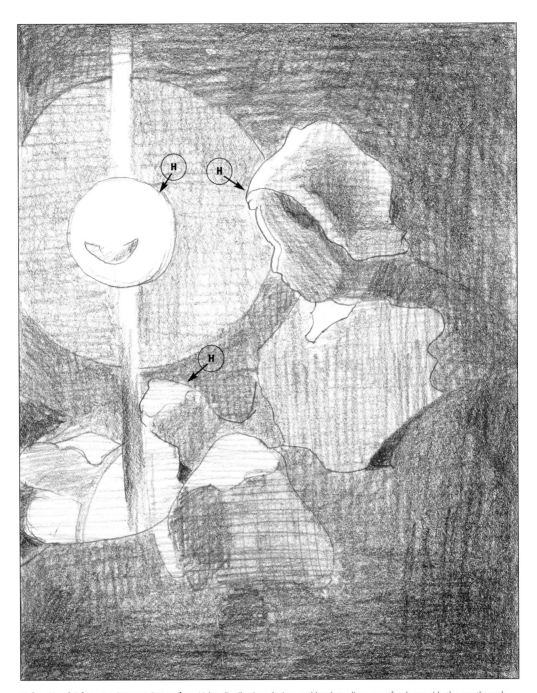

Using Hard Edges to Attract Attention Value distribution; design; and hard, medium, or soft edges guide the eye through a painting. As we saw on pages 36 and 37, focal points are mostly the result of contrast between light and dark values. But focal points are heightened even further when they also have hard edges. The eye first goes to the hard edges (H) in this painting. All the other edges become increasingly softer as the values become darker. The viewer's eye finds the softer edges far less interesting.

Copying in Pencil

Step 1 As usual, I lightly sketch the scene with an HB pencil. Except for the halo of light and its circular gradations into darkness, I use mostly straight lines, accurate angles, and negative shapes to draw the correct proportions. During this process, I constantly drop plumb lines and draw light horizontals for guidelines. For example, I drop a plumb line from the forehead to help me see that it lines up with the blanket below; I also draw a horizontal guide that lines up with the baby's face.

Step 2 Now, using those straight lines and accurate shapes, I begin to get more specific by adding curves, folds, facial features, hands, and smaller details. I try to keep this step accurate, so I won't need to make too many changes once the shading process begins. Wherever I plan to add shadows, I enclose the area with a light line. Take special notice of the shadow lines on the forehead and cheek.

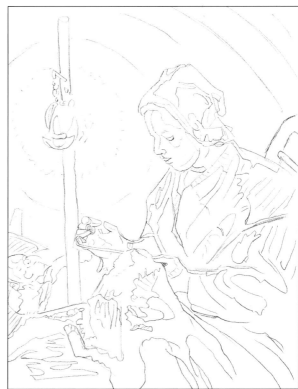

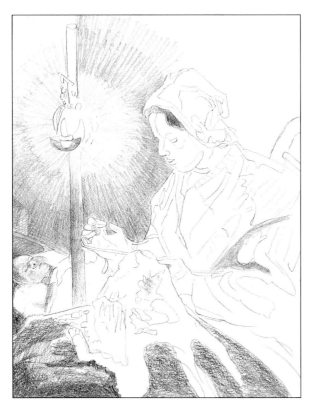

Step 3 You have been referred to value scales throughout this book. Again, the idea is to find a range of values between lightest light and darkest dark. In this drawing there are not too many middle values, and in terms of central interest, the dark hair next to the woman's brightly lit forehead is an important focal point. Here the untouched white paper is the lightest value, so my first step will be to find the darkest darks. Then I will establish the tones in between. I use an HB pencil with linear strokes to build up the tones around the light. I use a 2B pencil with sidestrokes and crosshatching to darken the bottom of the drawing.

Step 4 Now I switch over to a 4B pencil and slowly continue to darken everything with cross-hatching. I'm not sure what the woman is sewing, but whatever it is, I find I can duplicate its texture with little scribbled strokes. Although nothing is as dark now as it will eventually be, I try to develop the whole drawing with the same value relation-ships I want to achieve. To get the darkest darks, I use a 6B pencil.

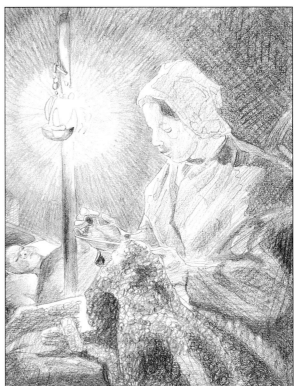

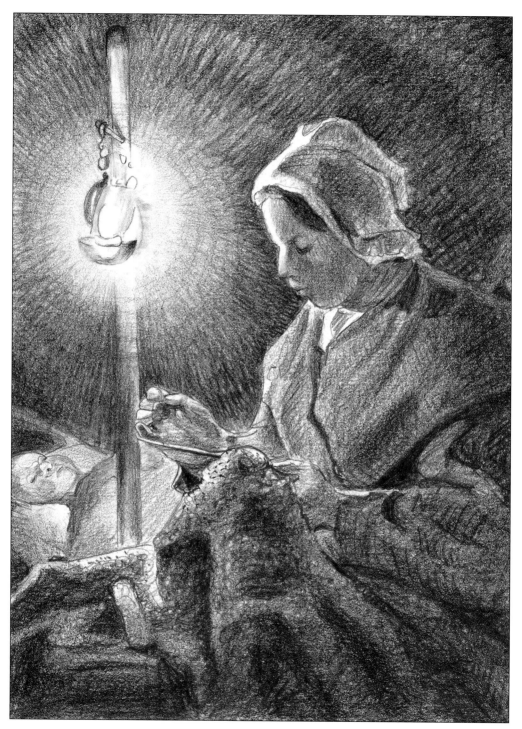

Step 5 In my final rendering, the only area where I let pure white paper show through is on the places of focal interest: the lantern; the woman's shirt; and the brightly illuminated edges of her face, bonnet, and hands. In all other areas, I subtly tone down the lights, gradually merging them into the darkness. I create the darkest darks mostly by crosshatching with a sharp 6B pencil. Recall how artificial light loses strength as it leaves its source (see page 27). This drawing is a perfect example of that phenomenon and of the use of hard and soft edges.

COMBINING THE ELEMENTS OF DESIGN

Line, value, texture, shape, size, and direction are the elements or main ingredients of which every drawing is made. As an artist, you must decide how and why each element should be used. On the following pages, I separately analyze and describe each element of this seascape. As you study each individual diagram, compare it with the final rendering on this page to see how each element functions properly in context with the others.

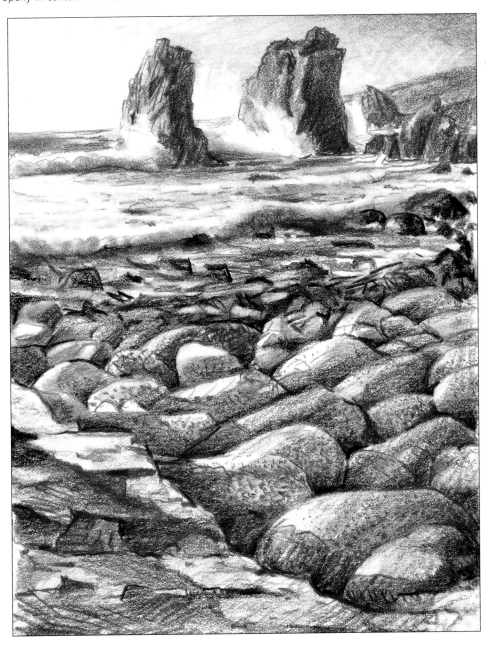

Making Use of Design Elements This seascape makes effective use of each of the elements of design. Over the next three pages, you'll see how each of the elements is used.

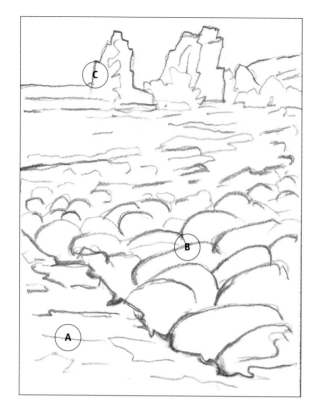

Line You learned on page 9 that lines do not exist in nature; they only exist in the two-dimensional world of drawing. Lines in this seascape are mainly used to separate values of light and dark. In the foreground, a variety of thick and thin lines adds textural complexity and interest (A). The lines around the boulders separate the foreground and background planes (B). The distant rocks use lines to show crevices on the sunlit side (C).

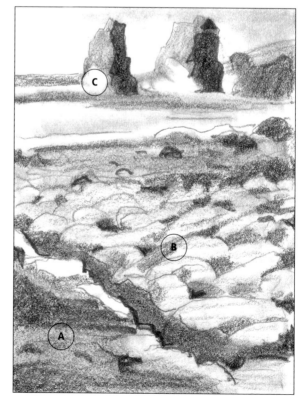

Value Never underestimate the importance of value in drawing. I would even venture to say that it is the most important of all the elements. Shapes, lines, and textures hold little interest without variations in value. The distant rocks are the center of interest, so they stand in greatest contrast to the lightest lights (C). The middle-ground boulders are basically middle values with only small accents of light and dark (B). The foreground rocks possess the same value as the more distant boulders, but they are shaped differently to avoid monotony (A).

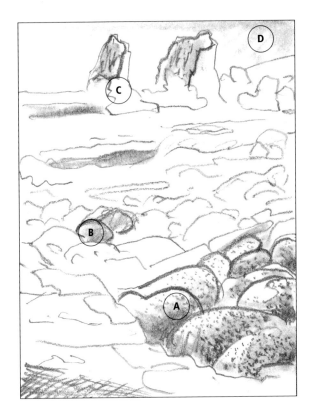

◄ **Texture** Conveying texture is a challenge because it is an invention of descriptive strokes. Texture is an antidote for monotony but can itself become monotonous if overemphasized. The foreground boulders are granite; small dots show their texture effectively (A). Farther back, the rocks become more atmospheric, and their textures become softer, with fewer dots (B). The distant rocks are a blend of dark softness and small linear markings because they need to stay atmospheric (C). The sky is shaded softly with lights lifted out with an eraser (D).

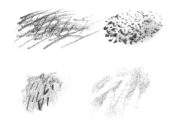

▲ **Seascape Textures** The textures I used for this seascape are shown above. (Also see "Basic Strokes" on page 6 for additional textures and strokes.)

▶ **Shape** I find it useful to identify shapes as square, round, and triangular, or modifications and combinations of these three basic categories. (See "Understanding Value and Shape" on page 7 for examples of these and other shapes.) None of the shapes in this seascape are clear-cut. The shapes in the foreground are short or long rectangular variations of a square (A). The boulders are round and oval variations of a rectangle (B). The distant rocks in the center are variants of a square (C), and the distant rocks on the right come closer to being triangular (D). Variations in size and value are key in eliminating monotony.

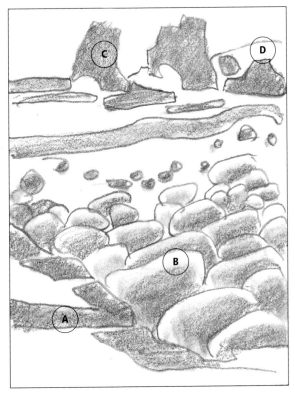

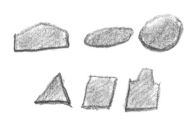

▲ **Seascape Shapes** The simple shapes that make up this seascape are shown above.

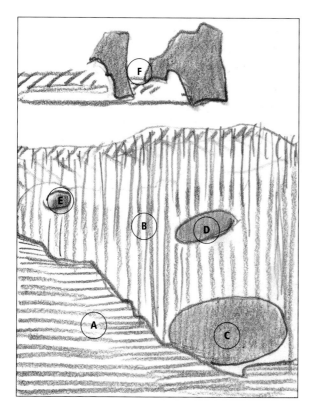

◄ Size In this seascape, size refers to both positive and negative shapes, especially in relation to the contrast between large and small. The eye requires variation to remain engaged, and a successful drawing keeps the viewer engaged. The smaller foreground area (A), with its diagonal, hard, straight edge, sets off the larger, softer area with its rounded boulders (B). The foreground boulders (C), middle-ground boulders (D), and background boulders (E) become progressively smaller, suggesting depth. The distant rocks differ slightly in size against the rectangular negative space (F).

▲ Varying Sizes Variations in size provide interest in your artwork.

▶ Direction Vertical, diagonal, and horizontal lines all engender emotional responses. A vertical direction expresses austerity and uprightness. Diagonal thrusts imply movement and dynamism. A horizontal line conveys tranquility and repose. All three directions are present in this seascape. Diagonal thrusts provide movement into the picture (B). The diagonal thrust is gently tempered by a counter-diagonal (C) and a horizontal foreground movement (A) that echoes the stable horizon (E). As diagonal thrusts come closer to the horizon, they flatten out and become more passive, as laws of perspective dictate they should (D). Finally, verticals reflect the overall uprightness of the picture itself (F).

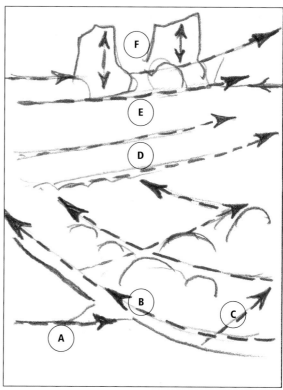

▲ Primary Directions The three main directions of movement are diagonal, horizontal, and vertical.

PULLING IT ALL TOGETHER

This straightforward portrait sums up many of the lessons you've learned. The reminders on the next page are important to remember because they cover the essence of building up any drawing.

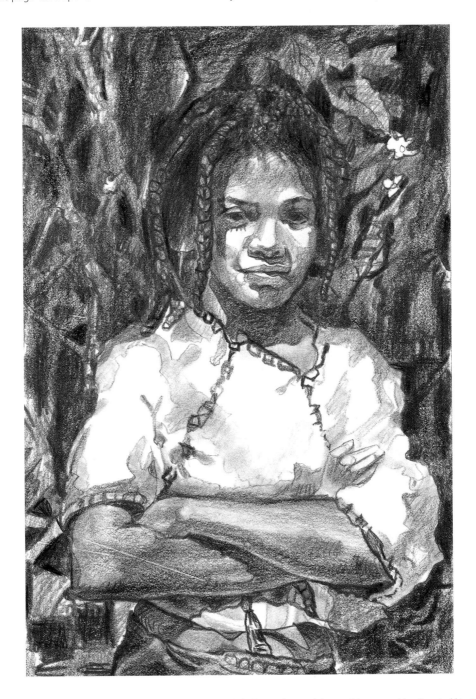

The Sum of Many Parts To create this portrait, I first establish the basic values and shapes of the composition. Then I add texture and refine the lines, shapes, and values.

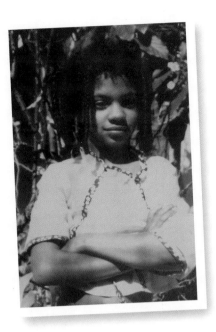

Modifying the Original Image This is a good photo from which to work, but the background is a bit distracting. The solution is to eliminate conflicting whites, then darken and unify the background.

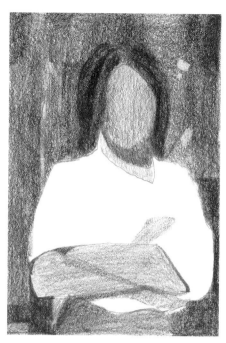

Creating a Thumbnail Value Study When I decide to reinterpret a photo, small thumbnail drawings direct me to my next interpretation. I still use the photo for details, but the value study becomes my reference map for light and dark values.

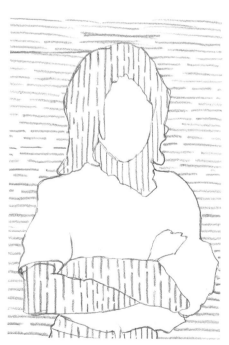

Recognizing Positive and Negative Shapes I block out the large shapes before adding details. Most people think concentration means focusing on a specific detail. To artists, it means focusing on the whole first and the parts later.

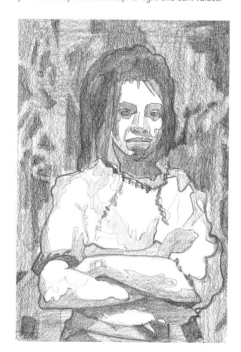

Refining the Composition With my basic shapes and values worked out, I can now fill in the gradations of line, shape, and value that will give the final rendering depth and dimension.

CLOSING THOUGHTS

The process of drawing can be divided into three stages: (1) absorbing optical sensations (seeing value and shape rather than "things"); (2) analyzing those sensations (knowing what you actually see and finding the best way to depict it); and (3) getting to work (having the courage to begin, with this book as a guide and a reference).

Let me remind you to hold onto the large shapes for a long time. It is always tempting to add too many details; simplicity is the strength of a drawing. With each attempt, you will go a little further and learn a little more. And remember that this journey is not about making perfect drawings: it's about making each drawing you create better than the one before it while having a good time.

There are plenty of important ideas in this book, but none of them are useful until they are put into practice. I recommend that you compose a setup, get out your pencils and paper, and practice your strokes. Make this book ragged through overuse! I wish you much success in your drawing adventures.